THE SAYINGS OF
BUDDHA

© 2011 Hugh L. Levin, LLC
Cover Design © 2011 Piccadilly (USA) Inc.

This edition published by Piccadilly (USA) Inc. by arrangement with Hugh L. Levin, LLC

Piccadilly (USA) Inc.
2658 Del Mar Heights Road, Suite 162
Del Mar, CA 92014
USA

10 9 8 7 6 5 4 3 2 1

Printed in China

ISBN-13: 978-1-60863-728-7

March 22, 1922

A gift to my angel Vanina. A gift from me, Nancy. Nothing in appreciation for all she does. I thank her.

Love Nancy

Better than a thousand hollow words, is one word that brings peace.
—BUDDHA

Do not dwell in the past, do not dream of the future, concentrate the mind on the present moment.

—BUDDHA

Chaos is inherent in all compounded things. Strive on with diligence.

—BUDDHA

Thousands of candles can be lit from a single candle, and the life of the candle will not be shortened. Happiness never decreases by being shared.

—BUDDHA

However many holy words you read, however many you speak, what good will they do you if you do not act on upon them?

—BUDDHA

Health is the greatest gift, contentment the greatest wealth, faithfulness the best relationship.

—BUDDHA

Holding on to anger is like grasping a hot coal with the intent of throwing it at someone else; you are the one who gets burned.

—BUDDHA

I do not believe in a fate that falls on men however they act; but I do believe in a fate that falls on them unless they act.

—BUDDHA

Speak or act with an impure mind and trouble will follow you.
—BUDDHA

In the sky, there is no distinction of east and west; people create distinctions out of their own minds and then believe them to be true.

—BUDDHA

I never see what has been done; I only see what remains to be done.

—BUDDHA

The wise ones fashioned speech with their thought, sifting it as grain is sifted through a sieve.

—BUDDHA

See the false as false, the true as true. Look into your heart. Follow your nature.

—BUDDHA

To be idle is a short road to death and to be diligent is a way of life; foolish people are idle, wise people are diligent.

—BUDDHA

In every trial let understanding fight for you.

—BUDDHA

To live a pure unselfish life, one must count nothing as one's own in the midst of abundance.

—BUDDHA

Virtue is persecuted more by the wicked than it is loved by the good.
 —BUDDHA

We are what we think. All that we are arises with our thoughts.
With our thoughts, we make the world.

—BUDDHA

An insincere and evil friend is more to be feared than a wild beast; a wild beast may wound your body, but an evil friend will wound your mind.

—BUDDHA

Whatever words we utter should be chosen with care for people will hear them and be influenced by them for good or ill.

—BUDDHA

Work out your own salvation. Do not depend on others.

—BUDDHA

You yourself, as much as anybody in the entire universe, deserves your love and affection.

—BUDDHA

You will not be punished for your anger, you will be punished by your anger.

—BUDDHA

No one saves us but ourselves. No one can and no one may.
We ourselves must walk the path.

—BUDDHA

It is better to travel well than to arrive.
 —BUDDHA

Just as treasures are uncovered from the earth, so virtue appears from good deeds, and wisdom appears from a pure and peaceful mind.

—BUDDHA

Peace comes from within. Do not seek it without.

—BUDDHA

When one has the feeling of dislike for evil, when one feels tranquil, one finds pleasure in listening to good teachings; when one has these feelings and appreciates them, one is free of fear.

—BUDDHA

The foot feels the foot when it feels the ground.
 —BUDDHA

The whole secret of existence is to have no fear. Never fear what will become of you, depend on no one. Only the moment you reject all help are you freed.

—BUDDHA

The mind is everything. What you think you become.

—BUDDHA

The virtues, like the Muses, are always seen in groups. A good principle was never found solitary in any breast.

—BUDDHA

The tongue like a sharp knife . . . kills without drawing blood.

—BUDDHA

There are only two mistakes one can make along the road to truth; not going all the way, and not starting.

—BUDDHA

The way is not in the sky. The way is in the heart.

—BUDDHA

As a mother would risk her life to protect her child, her only child, even so should one cultivate a limitless heart with regard to all beings.

—BUDDHA

The only real failure in life is not to be true to the best one knows.

—BUDDHA

There is nothing more dreadful than the habit of doubt. Doubt separates people. It is a poison that disintegrates friendships and breaks up pleasant relations.

—BUDDHA

There has to be evil so that good can prove its purity above it.

—BUDDHA

We are shaped by our thoughts, we become what we think. When the mind is pure, joy follows.

—BUDDHA

Those who are free of resentful thoughts surely find peace.
 —BUDDHA

To enjoy good health, to bring true happiness to one's family, to bring peace to all, one must first discipline and control one's own mind.

—BUDDHA

Hatred does not cease by hatred, but only by love; this is the eternal rule.

—BUDDHA

Three things cannot be long hidden: the sun, the moon, and the truth.
—BUDDHA

By your own folly you will be brought as low as your worst enemy wishes.

—BUDDHA

All wrong-doing arises because of mind. If mind is transformed can wrong-doing remain?

—BUDDHA

By your own efforts waken yourself, watch yourself. And live joyfully.
You are the master.

—BUDDHA

An idea that is developed and put into action is more important than an idea that exists only as an idea.

—BUDDHA

To understand everything is to forgive everything.
—BUDDHA

Why do what you will regret? Why bring tears upon yourself? Do only what you do not regret, and fill yourself with joy.

—BUDDHA

Look not for recognition but follow the awakened and set yourself free.

—BUDDHA

A dog is not considered a good dog because he is a good barker. A man is not considered a good man because he is a good talker.

—BUDDHA

You cannot travel the path until you have become the path itself.

—BUDDHA

Believe nothing, no matter where you read it, or who said it, no matter if I have said it, unless it agrees with your own reason and your own common sense.

—BUDDHA

A jug fills drop by drop.
 —BUDDHA

Teach this triple truth to all: a generous heart, kind speech, and a life of service and compassion are the things which renew humanity.

—BUDDHA

To conquer oneself is a greater task than conquering others.

—BUDDHA

Have compassion for all beings, rich and poor alike; each has their suffering. Some suffer too much, others too little.

—BUDDHA

To keep the body in good health is a duty . . . otherwise we shall not be able to keep our mind strong and clear.

—BUDDHA

Your work is to discover your work and then with all your heart to give yourself to it.

—BUDDHA

Crushing out of the conceit "I am"—this is the highest happiness.

—BUDDHA

You too shall pass away. Knowing this, how can you quarrel?
—BUDDHA

You are the source of all purity and impurity. No one purifies another.

—BUDDHA

To share happiness, and to have done something good before leaving
this life is sweet.

— BUDDHA

Every human being is the author of his own health or disease.

— BUDDHA

Winning gives birth to hostility Losing, one lies down in pain. The calmed lie down with ease, having set winning and losing aside.

—BUDDHA

Hold fast to Truth as a lamp; hold fast to the truth as a refuge.

—BUDDHA

It is better to do nothing than to do what is wrong. For whatever you do, you do to yourself.

— BUDDHA

If desires are not uprooted, sorrows grow again in you.
—BUDDHA

If he is a good man, a man of faith, honored and prosperous, wherever he goes he is welcome.

—BUDDHA

It is a man's own mind, not his enemy or foe, that lures him to evil ways.

—BUDDHA

The fragrance of sandalwood and rosebay does not travel far. But the fragrance of virtue rises to the heavens.

— BUDDHA

Neither fire nor wind, birth nor death can erase our good deeds.

—BUDDHA

On a long journey of human life, faith is the best of companions; it is the best refreshment on the journey; and it is the greatest property.

—BUDDHA

The greatest prayer is patience.

— BUDDHA

With gentleness overcome anger. With generosity overcome meanness. With truth overcome deceit.

— BUDDHA

May all beings be happy at heart.
—BUDDHA

Let go of anger. Let go of pride. When you are bound by nothing you go beyond sorrow.

— BUDDHA

Desire never crosses the path of virtuous and wakeful men.

—BUDDHA

Let no one deceive another or despise anyone anywhere, or through anger
or irritation wish for another to suffer.

—BUDDHA

The wise have mastered body, word, and mind. They are the true masters.

—BUDDHA

How easily the wind overturns a frail tree. Seek happiness in the senses, indulge in food and sleep, and you too will be uprooted.

—BUDDHA

The ignorant man is an ox. He grows in size, not in wisdom.

—BUDDHA

Whoever is master of his own nature, bright, clear, and true, he may indeed wear the yellow robe.

—BUDDHA

Understand that the body is merely the foam of a wave, the shadow of a shadow.

—BUDDHA

How easy it is to see your brother's faults, how hard it is to face your own.

—BUDDHA

Free from passion and desire, you have stripped the thorns from the stem.

—BUDDHA

Look not to the faults of others, nor to their omissions and commissions. But rather look to your own acts, to what you have done and left undone.

—BUDDHA

There is pleasure and there is bliss. Forgo the first to possess the second.

—BUDDHA

The true master lives in truth, in goodness and restraint, non-violence, moderation, and purity.

—BUDDHA

Fresh milk takes time to sour. So a fool's mischief takes time to catch up with him.

—BUDDHA

Do what you have to do resolutely, with all your heart. The traveler who hesitates only raises dust on the road.

—BUDDHA

Awake. Be the witness of your thoughts.
　　　　　　—BUDDHA

"As I am, so are others; as others are, so am I." Having thus identified self and others, harm no one nor have them harmed.

—BUDDHA

Beware of the anger of the body. Master the body. Let it serve truth.

—BUDDHA

The wind cannot overturn a mountain. Temptation cannot touch the man who is awake, strong, and humble, who masters himself and minds the law.

—BUDDHA

The greatest impurity is ignorance. Free yourself from it. Be pure.

—BUDDHA

For a while the fool's mischief tastes sweet, sweet as honey. But in the end it turns bitter. And how bitterly he suffers!

—BUDDHA

Beware of the anger of the mouth. Master your words. Let them serve truth.

—BUDDHA

One is not low because of birth nor does birth make one holy. Deeds alone make one low, deeds alone make one holy.

—BUDDHA

Happiness or sorrow—whatever befalls you, walk on untouched, unattached.

—BUDDHA

A wise man, recognizing that the world is but an illusion, does not act as if it is real, so he escapes the suffering.

—BUDDHA

Beware of the anger of the mind. Master your thoughts. Let them serve truth.

—BUDDHA

Be quick to do good. If you are slow, the mind, delighting in mischief, will catch you.

—BUDDHA

Does the spoon taste the soup? A fool may live all his life in the company of a master and still miss the way.

—BUDDHA

Endurance is one of the most difficult disciplines, but it is to the one who endures that the final victory comes.

—BUDDHA

Live joyfully, without desire.
　　—BUDDHA

The rain could turn to gold and still your thirst would not be slaked.
Desire is unquenchable or it ends in tears, even in heaven.

—BUDDHA

If the traveler cannot find master or friend to go with him, let him travel alone rather than with a fool for company.

—BUDDHA

Follow the way of virtue. Follow the way joyfully through this world and on beyond.

—BUDDHA

If you are happy at the expense of another man's happiness, you are forever bound.

—BUDDHA

Good men and bad men differ radically. Bad men never appreciate kindness shown them, but wise men appreciate and are grateful.

—BUDDHA

It is you who must make the effort. Masters only point the way.

—BUDDHA

A good friend who points out mistakes and imperfections and rebukes evil is to be respected as if he reveals a secret of hidden treasure.

—BUDDHA

Let a man avoid evil deeds as a man who loves life avoids poison.

—BUDDHA

The farmer channels water to his land. The fletcher whittles his arrows. And the carpenter turns his wood. So the wise man directs his mind.

—BUDDHA

The fool laughs at generosity. The miser cannot enter heaven. But the master finds joy in giving and happiness is his reward.

—BUDDHA

His success may be great, but be it ever so great the wheel of fortune may turn again and bring him down into the dust.

—BUDDHA

Ye must leave righteous ways behind, not to speak of unrighteous ways.
—BUDDHA

Nothing is infallible. Nothing is binding forever. Every thing is subject to inquiry and examination.

—BUDDHA

As the shadow follows the body, as we think, so we become.
—BUDDHA

He who for the sake of happiness hurts others who also want happiness, shall not hereafter find happiness.

—BUDDHA

Let a man overcome anger by love.
—BUDDHA

There is no fire like passion, there is no shark like hatred, there is no snare like folly, there is no torrent like greed.

—BUDDHA

Watch the thought and its ways with care, and let it spring from love born out of concern for all beings.

<div align="right">—BUDDHA</div>

Yet the Teaching is simple. Do what is right. Be pure. At the end of the way is freedom.

—BUDDHA

Do not what is evil. Do what is good. Keep your mind pure. This is the teaching.

—BUDDHA

Corporeality is transient, feeling is transient, perception is transient, mental formations are transient, consciousness is transient.

—BUDDHA

Nothing brings joy as does a tamed, controlled, attended, and restrained heart. This heart brings joy.

—BUDDHA

Just as a solid rock is not shaken by the storm, even so the wise are not affected by praise or blame.

—BUDDHA

If a man going down into a river, swollen and swiftly flowing, is carried away
by the current—how can he help others across?

—BUDDHA

One truly is the protector of oneself; who else could the protector be? With oneself fully controlled, one gains a mastery that is hard to gain.

—BUDDHA

Do not live in the world, in distraction and false dreams, outside the dharma.

—BUDDHA

The glorious chariots of kings wear out, and the body wears out and grows old; but the virtue of the good never grows old.

—BUDDHA

If he makes himself as good as he tells others to be, then he in truth can teach others. Difficult indeed is self-control.

—BUDDHA

With good will for the entire cosmos, cultivate a limitless heart: above, below, and all around, unobstructed, without hostility or hate.

—BUDDHA

Overcome the angry by non-anger; overcome the wicked by goodness;
overcome the miser by generosity; overcome the liar by truth.

—BUDDHA

Wonderful it is to train the mind so swiftly moving, seizing whatever it wants. Good is it to have a well-trained mind, for a well-trained mind brings happiness.

—BUDDHA

Make an island of yourself, make yourself your refuge; there is no other refuge.
Make truth your island, make truth your refuge; there is no other refuge.

—BUDDHA

Were there a mountain all made of gold, doubled that would not be enough to satisfy a single man: know this and live accordingly.

—BUDDHA

Knowing that the other person is angry, one who remains mindful and calm acts for his own best interest and for the other's interest, too.

—BUDDHA

How long the night to the watchman, how long the road to the weary traveler, how long the wandering of many lives to the fool who misses the way.

—BUDDHA

Better it is to live one day seeing the rise and fall of things than to live a hundred years without ever seeing the rise and fall of things.

—BUDDHA

Whatever an enemy might do to an enemy, or a foe to a foe, the ill-directed mind can do to you even worse.

—BUDDHA

Learn this from the waters: in mountain clefts and chasms, loud gush the streamlets, but great rivers flow silently.

—BUDDHA

Easy to do are things that are bad and harmful to oneself. But exceedingly difficult to do are things that are good and beneficial.

—BUDDHA

Your worst enemy cannot harm you as much as your own thoughts, unguarded.

—BUDDHA

Just as a tree, though cut down, sprouts up again if its roots remain uncut and firm, even so, until the craving that lies dormant is rooted out, suffering springs up again and again.

—BUDDHA

Look within. Be still.

 —BUDDHA

Though one may conquer a thousand times a thousand men in battle, yet he indeed is the noblest victor who conquers himself.

—BUDDHA